MARY

WE'RE SO HAPPY TO

SHARE THIS GRANDPA [...]

JOURNEY THROUGH LIFE [...]

YOU! MAYBE THIS WILL BE

A GOOD INSPIRATION TO HELP

REMAIN "HUMOROUS & MEANINGFUL"!

ALL THE BEST,

Dede + Al

that's life

that's life

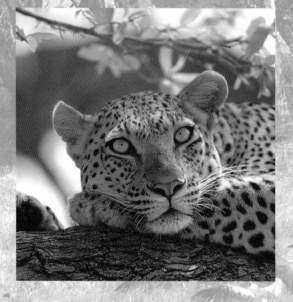

humorous and meaningful quotes on life

edited by tom burns

BARRON'S

First edition for North America produced 2005
by Barron's Educational Series, Inc.

© 2005 Axis Publishing Limited

All inquiries should be addressed to:
Barron's Educational Series, Inc.
250 Wireless Boulevard
Hauppauge, New York 11788
www.barronseduc.com

Library of Congress Catalog No: 2004118336

ISBN 13: 978-0-7641-5880-3
ISBN 10: 0-7641-5880-5

Conceived and created by
Axis Publishing Limited
8c Accommodation Road
London NW11 8ED
www.axispublishing.co.uk

Creative Director: Siân Keogh
Designer: Simon de Lotz
Editorial Director: Anne Yelland
Production Manager: Jo Ryan

Printed and bound in China

9 8 7 6 5 4 3 2 1

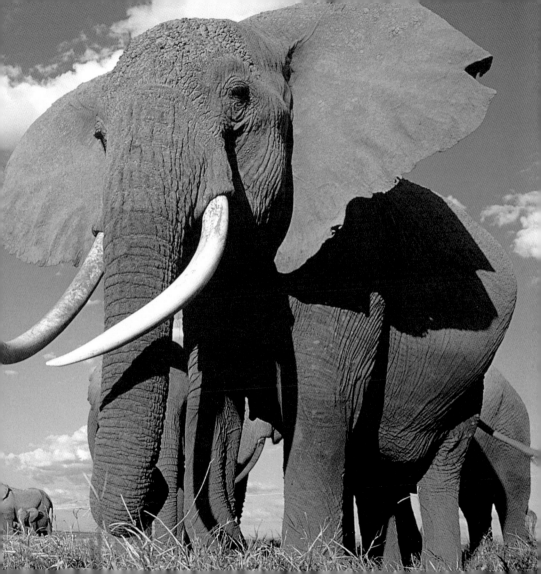

about this book

That's Life is a celebration of life through its major moments, from falling in love to retirement. It offers words of wisdom at these key times, highlighting their significance, magic, and wonder.

These thought-provoking and inspiring sayings and mantras are complemented by a collection of gently amusing animal photographs. This is an ideal gift book to raise a smile, offer words of wisdom, and generally revel in the life-affirming power of thought. We all lead stressful lives, and sometimes we forget to take a step back and smile at ourselves and our lives.

These inspiring examples of wit and wisdom, distilled from true-life experiences of people from many walks of life, sum up the essence of why life is amusing, quirky, and fun.

about the author

Tom Burns has written for a range of magazines and edited more than a hundred books on subjects as diverse as games and sports, cinema, history, and health and fitness. From the many hundreds of contributions that were sent to him by people giving their take on life, he has selected the ones that best sum up the idiosyncrasies and quirks of everyday life.

Please continue to send in your views, feelings, and advice about life—you never know, you too might see your words of wisdom in print one day!

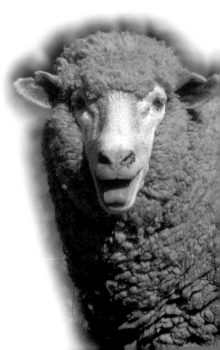

A characteristic of normal children is that they don't act that way very often.

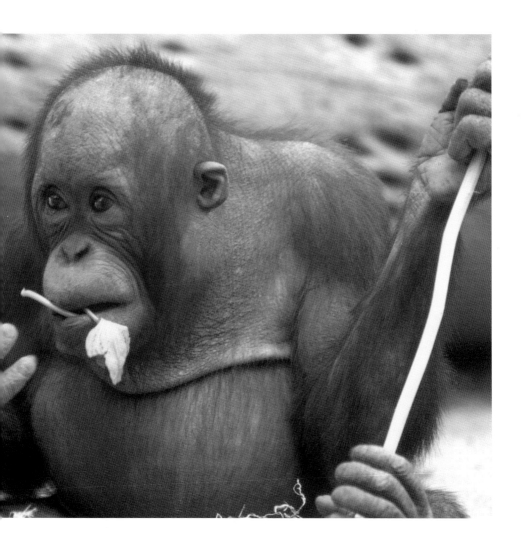

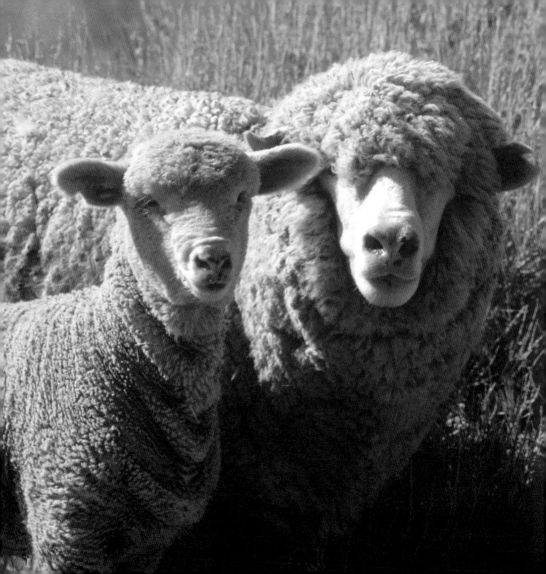

Children seldom misquote you. In fact, they usually repeat word for word what you shouldn't have said.

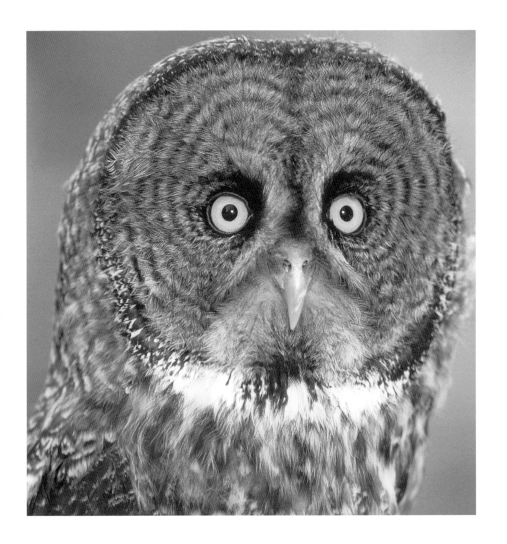

If you have a college degree,
you can be absolutely
sure of one thing…

…you have a college degree.

Those parts of the system
that you can hit with
a hammer are called
hardware; the instructions
that you can only curse
at are called software.

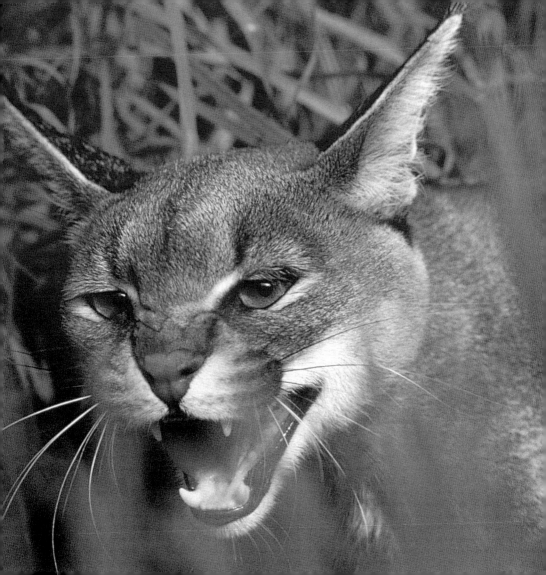

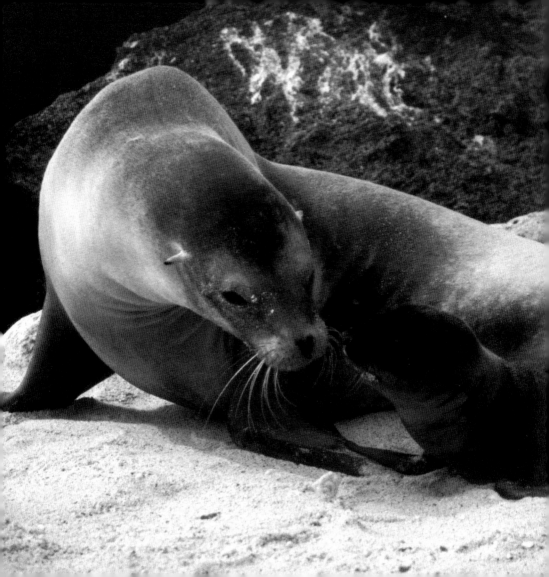

What you don't
know takes a lot
of explaining to
the children.

Back up my hard drive?
How do I put it in reverse?

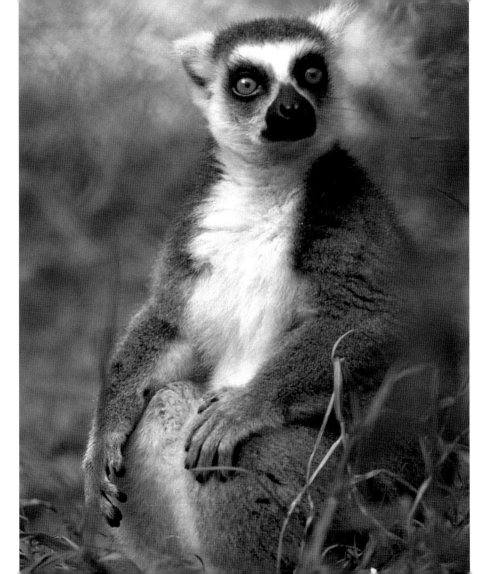

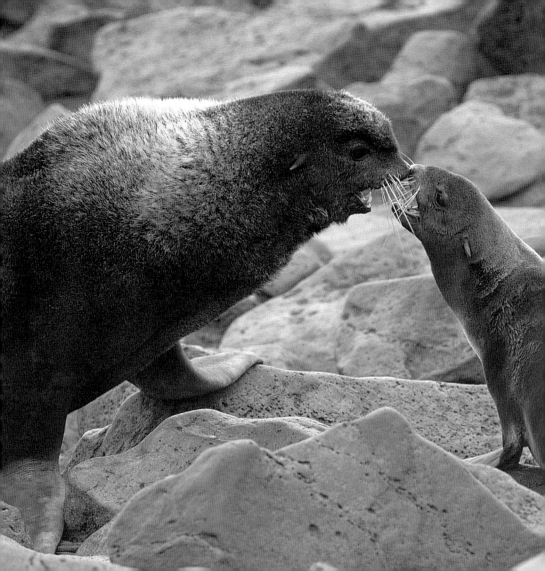

Experience is what you
get from not having it
when you needed it.

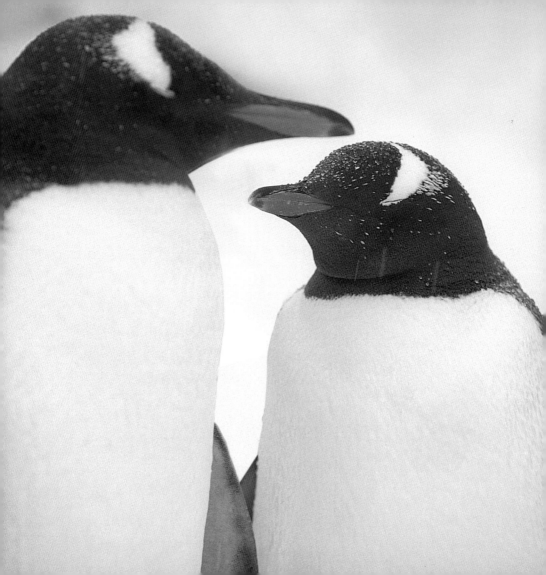

Conscience: Telling your mother what you've done before your brother or sister gets a chance to.

There's nothing wrong with the younger generation that paying taxes won't cure.

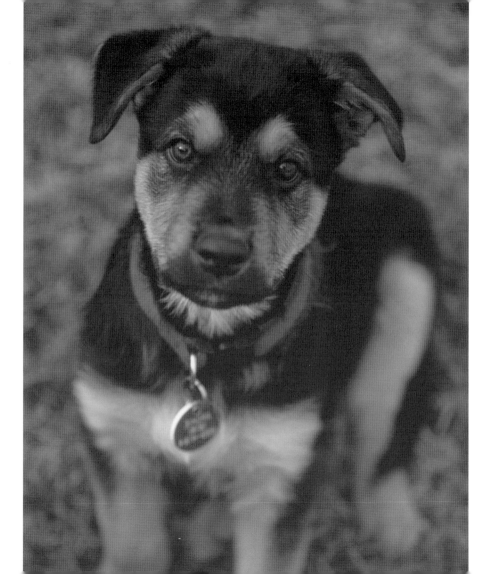

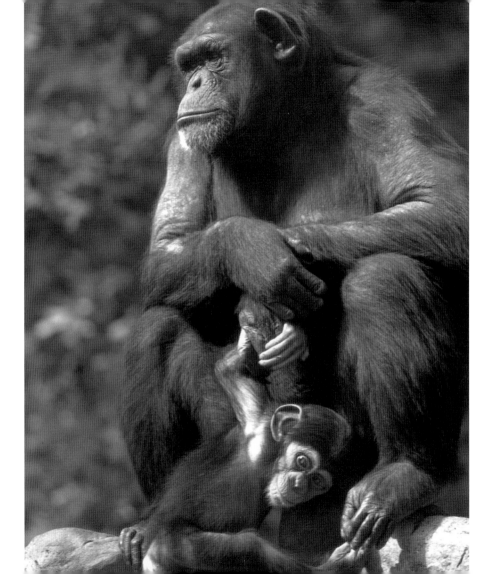

The easiest way to keep your kids at home is to let the air out of their tires.

Sleeping is the highest
accomplishment of genius.

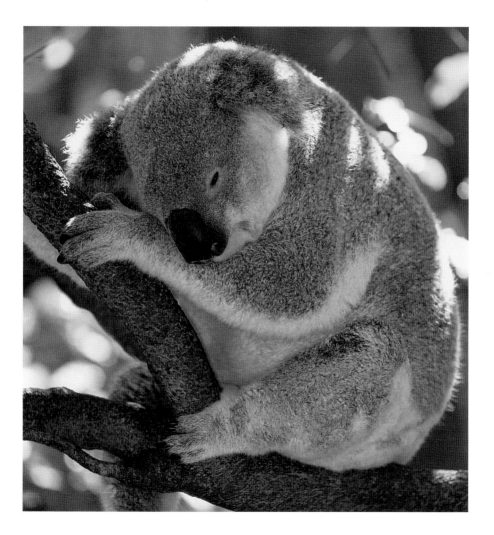

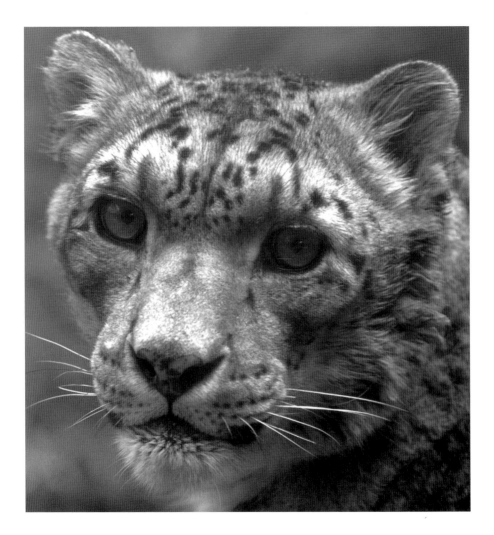

There is nothing wrong
with today's teenagers that
twenty years won't cure.

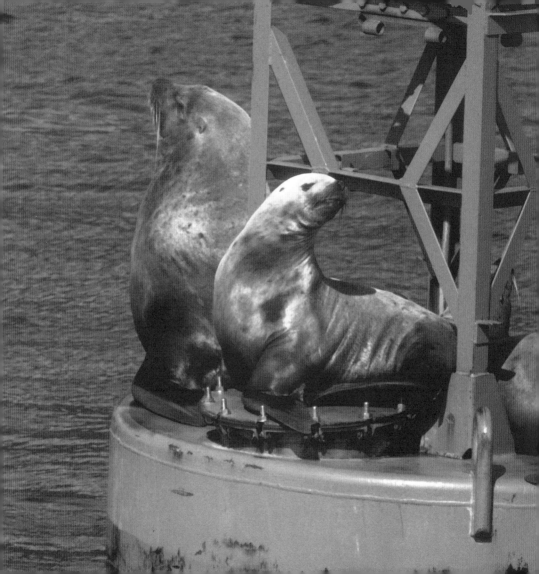

The average teenager still has all the faults his parents outgrew.

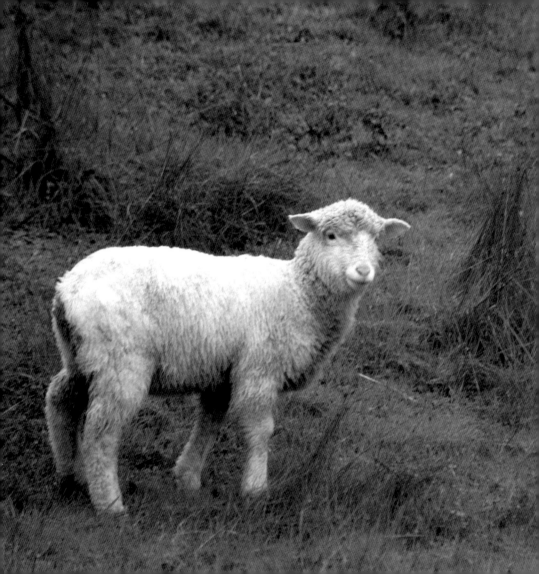

You can tell a child is growing up when he stops asking where he came from and starts refusing to tell where he is going.

Kids pick up driving
a car easily…

…but never seem to
master the lawnmower.

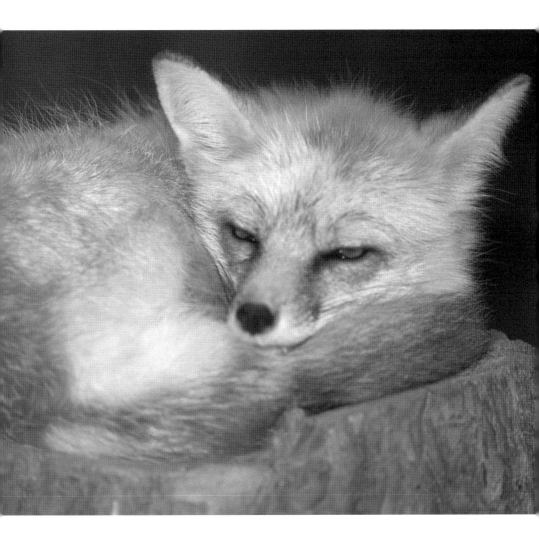

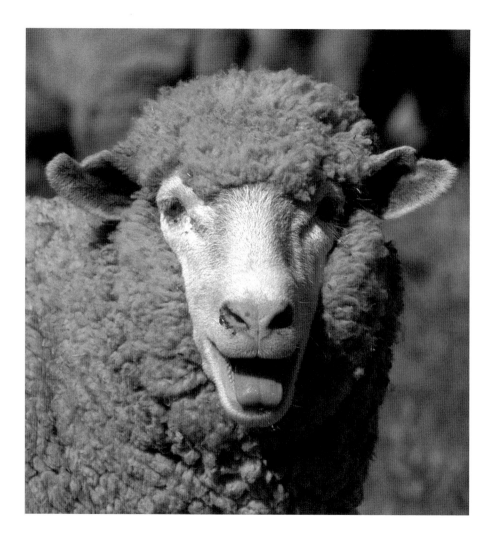

You're only young once, but you can stay immature forever.

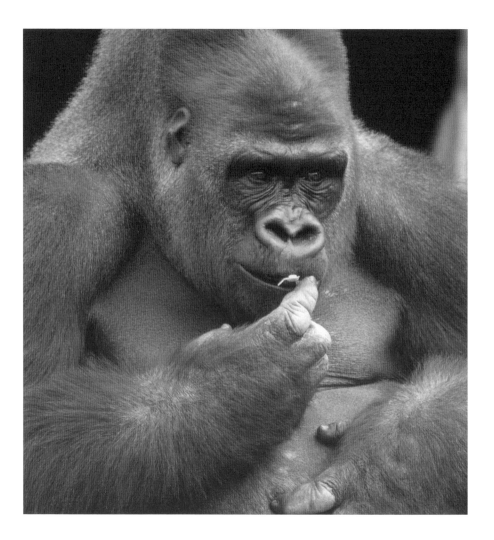

The purpose of a liberal education is to make you philosophical enough to accept the fact that you will never make much money.

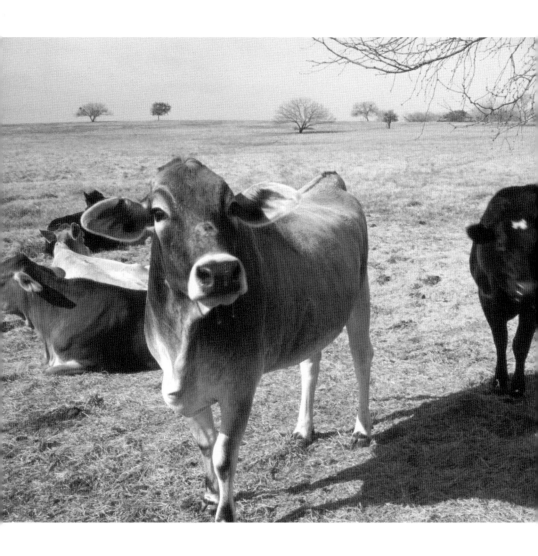

Vacation: A period of travel and relaxation when you take twice the clothes and half the money you need.

Why is there so much difference between a day off and an off day?

There's a very fine line between fishing and standing on the shore like an idiot.

Many people quit looking for work when they find a job.

The brain starts working the moment you wake up and doesn't stop until you get into the office.

Give a person a fish, and
you feed them for a day;
teach that person to use
the Internet, and they
won't bother you
for weeks.

Accomplishing the impossible means your boss will add it to your job description.

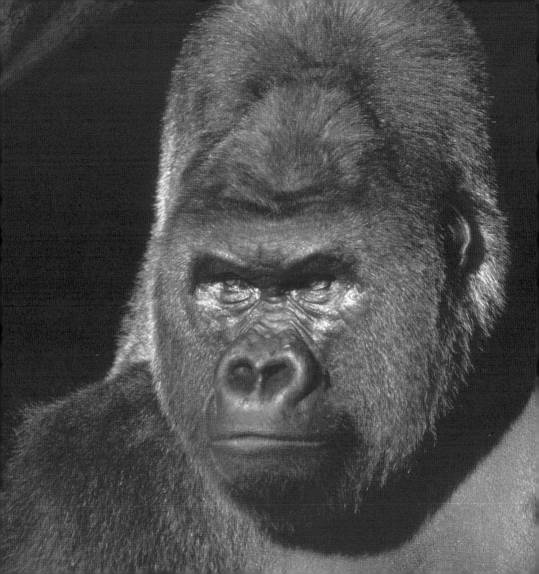

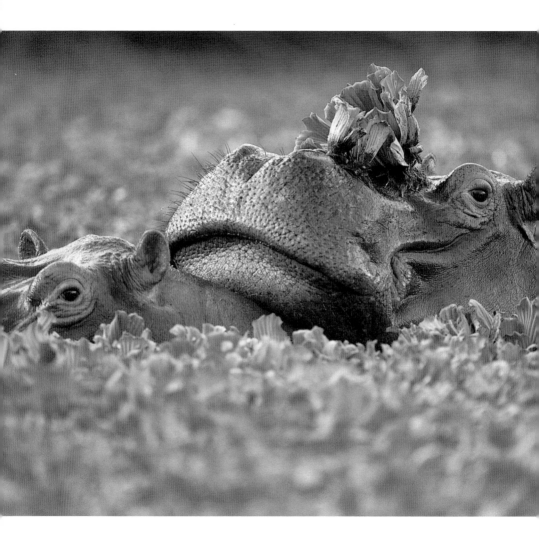

I'm not lazy…

…I'm resting before
I get tired.

The only job where
you start at the top
is digging a hole.

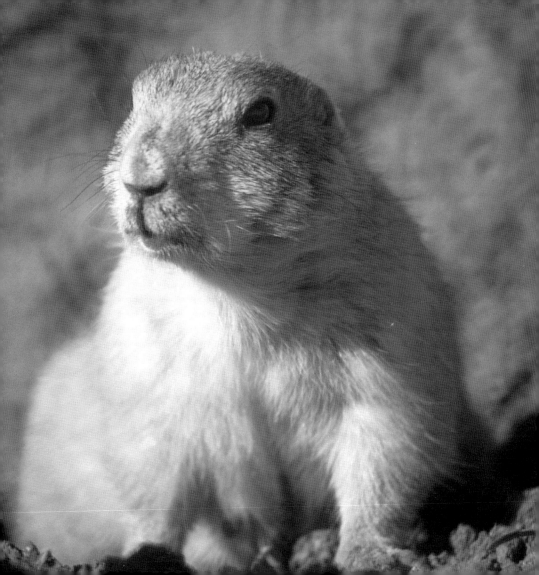

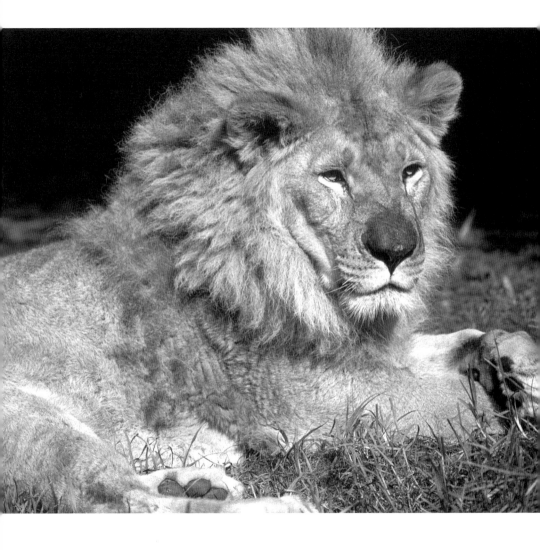

A man's reputation rarely outlasts his money.

Time is an illusion,
lunchtime even more so.

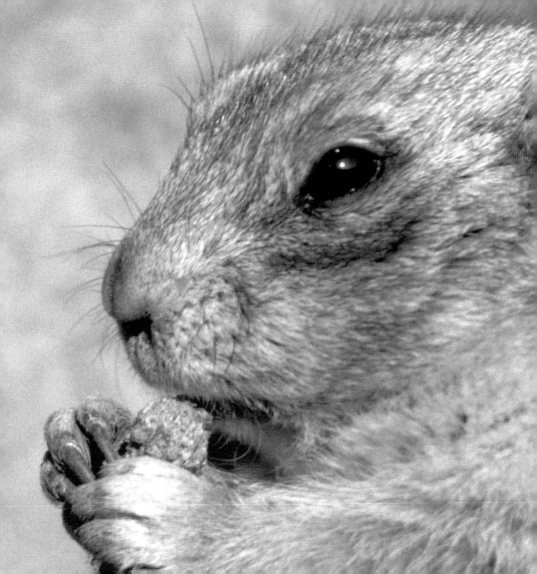

Tomorrow is
the busiest day
of the week.

If you know all the answers,
no one will ask you the questions.

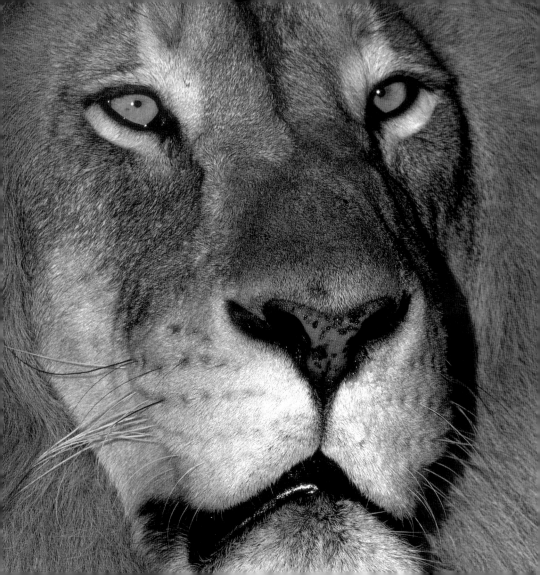

If it weren't for the last minute, I'd never get anything done.

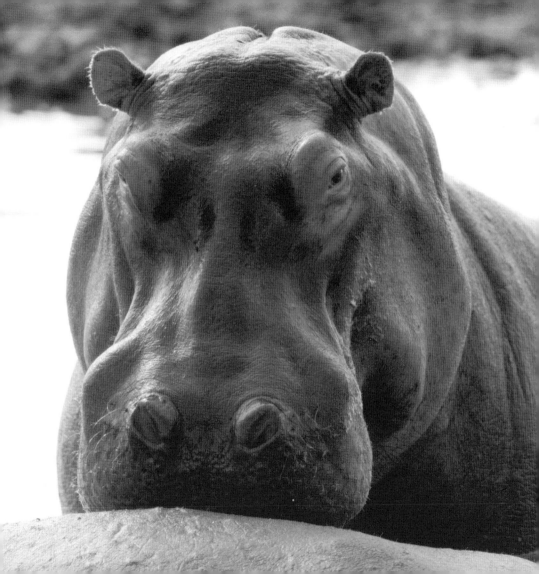

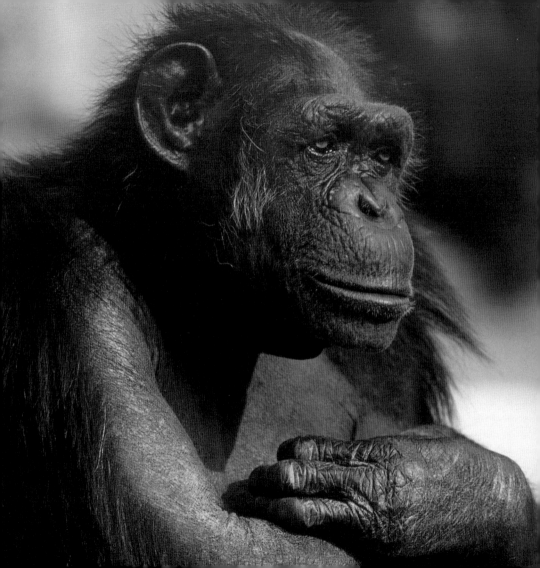

What's the point of being a genius if you can't use it as an excuse for being unemployed?

If at first you don't succeed, you're about average.

A woman's work is never done, especially the part she asks her husband to do.

If work is so great, why did the rich stop doing it?

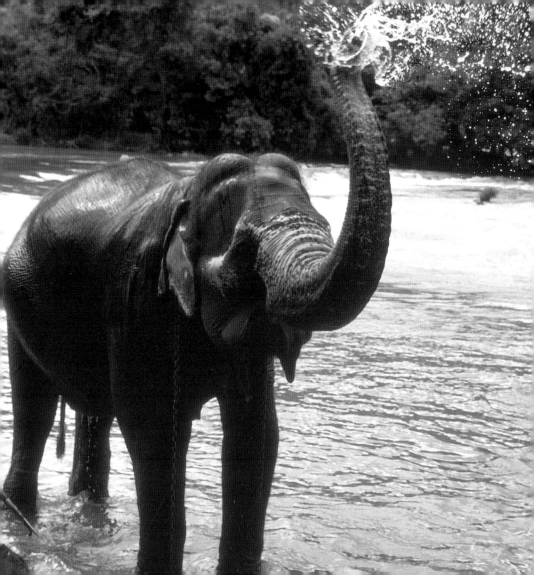

Have you ever noticed that "the" and "IRS" spells "theirs"?

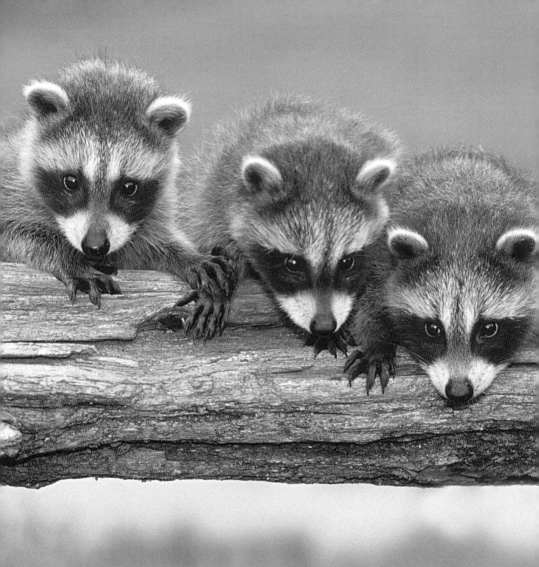

If two wrongs don't make a right, try three.

If you think your boss is an idiot,
remember you wouldn't have
a job if he was any smarter.

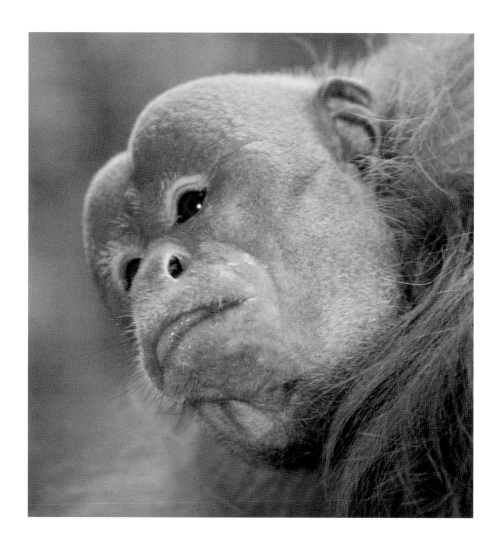

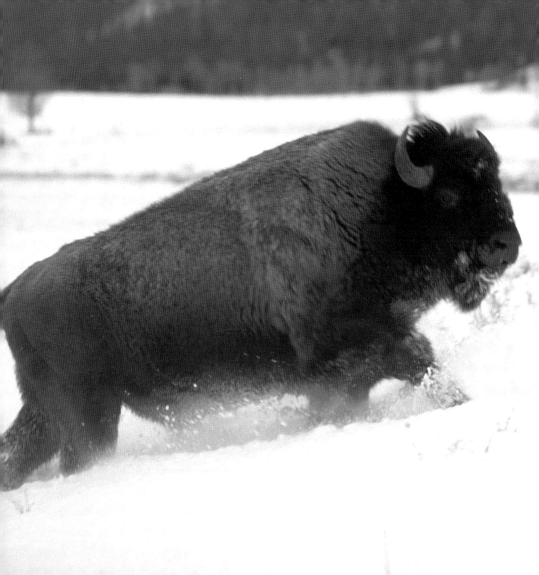

Work hard for eight hours a day and you might just get promoted and have to work twelve hours a day.

Love is a highly desirable
malfunction of the heart
which weakens the brain,
causes eyes to sparkle,
cheeks to glow, blood
pressure to rise, and
lips to pucker.

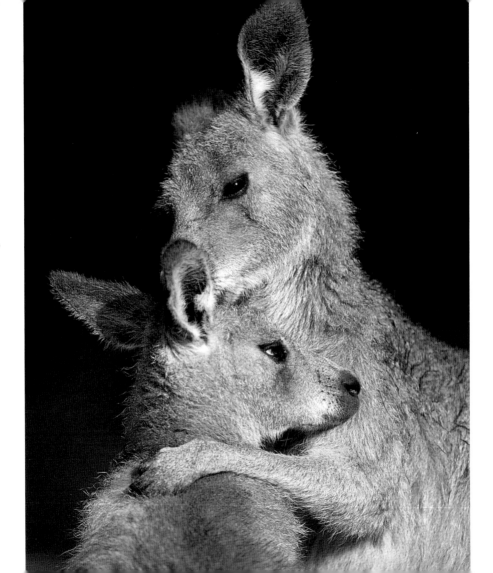

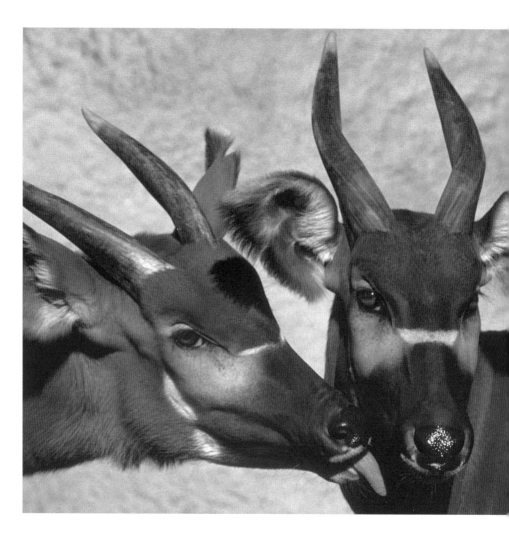

Trip over love and
you can get up.
Fall in love and
you fall forever.

Love is the most important
thing in the world…

…and baseball's pretty good too.

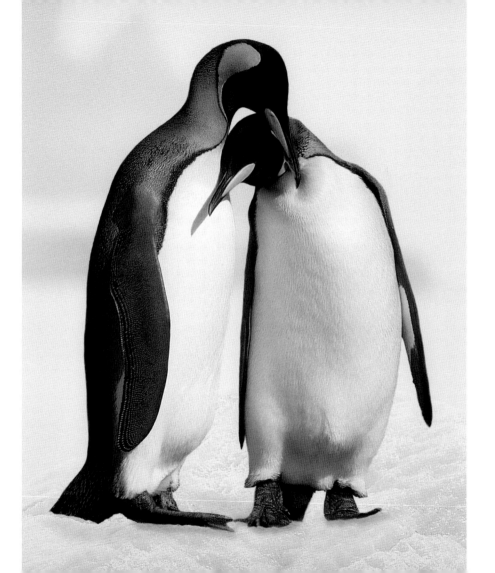

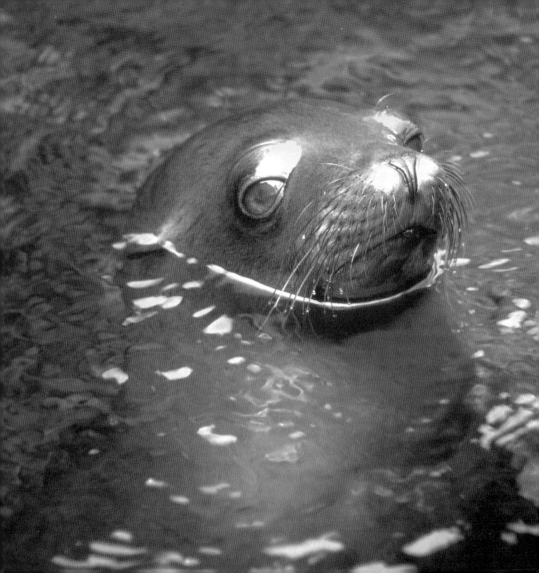

Forget love...

...I'd rather fall in chocolate!

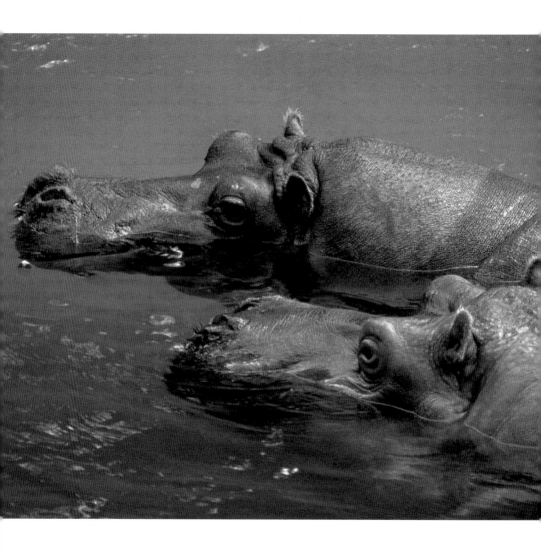

Love means
nothing in tennis,
but everything in life.

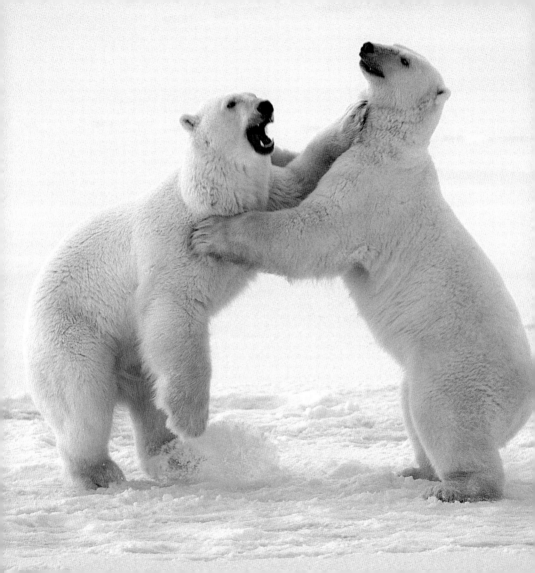

A husband will stand
by you through all the
troubles you wouldn't have
had if you'd stayed single.

Marriage, like insanity,

means commitment.

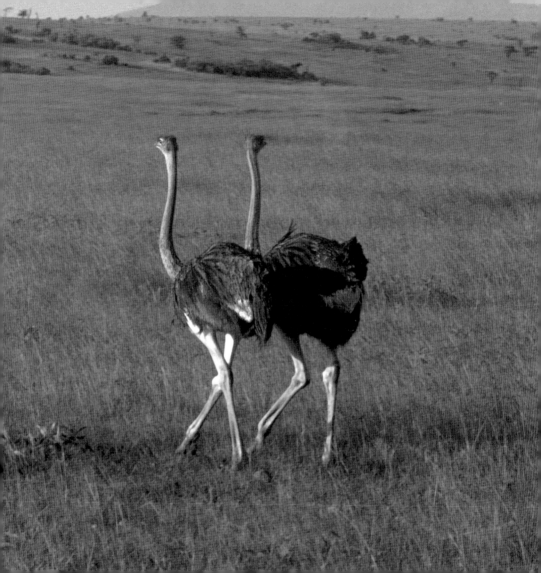

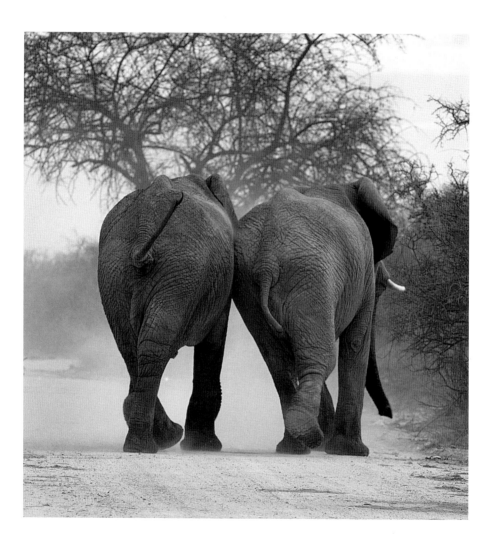

Never marry for money…

…it's cheaper to borrow it.

Marriage changes passion—
suddenly you're in bed
with a relative.

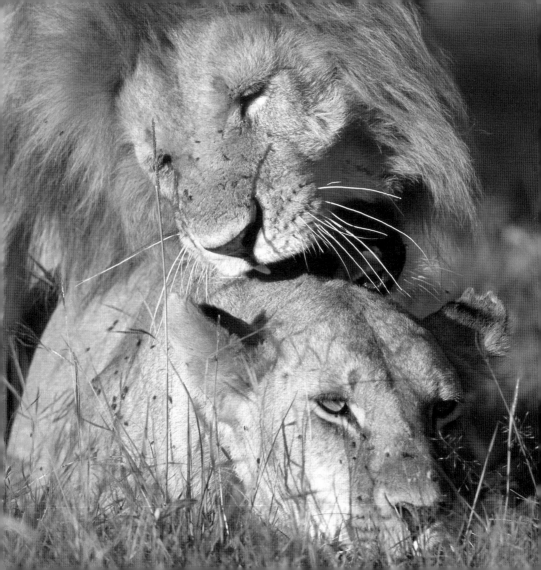

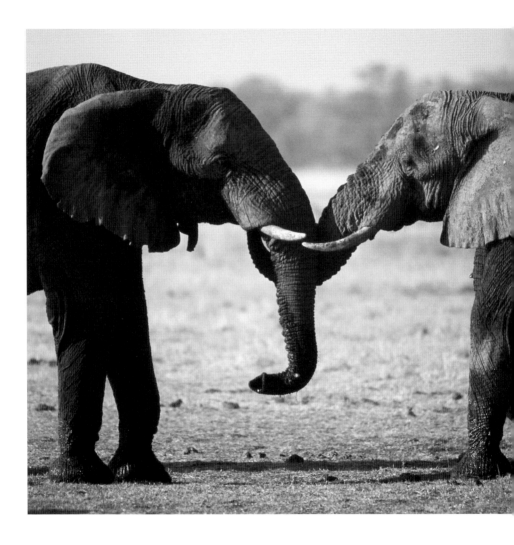

A perfect wife is one
who helps her husband
with the dishes.

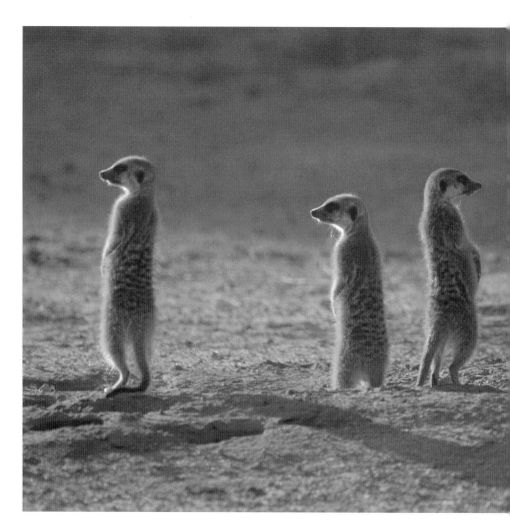

Football: A game devised
for padded cells played
in the open air.

Not knowing the
rules puts you on the
same level as the referee.

Monday is a dumb way to spend one seventh of your life.

If winning isn't everything,
why do they keep score?

Middle age is when work is a lot less fun and fun is a lot more work.

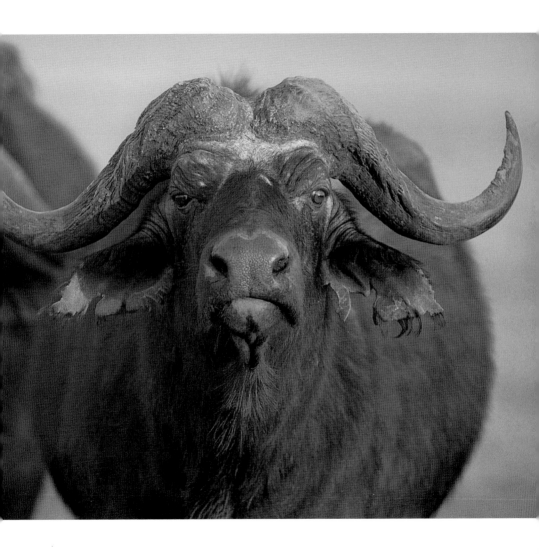

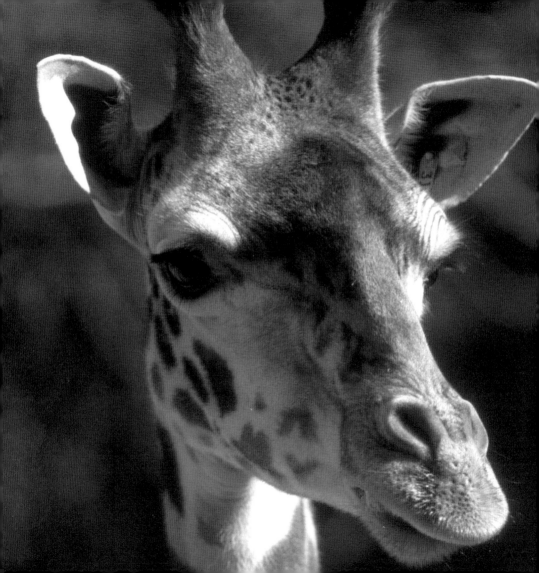

Middle age is when you have a choice between two temptations and you choose the one that will get you home earlier.

Lots of people talk to animals…

…the problem is that not many people listen to animals.

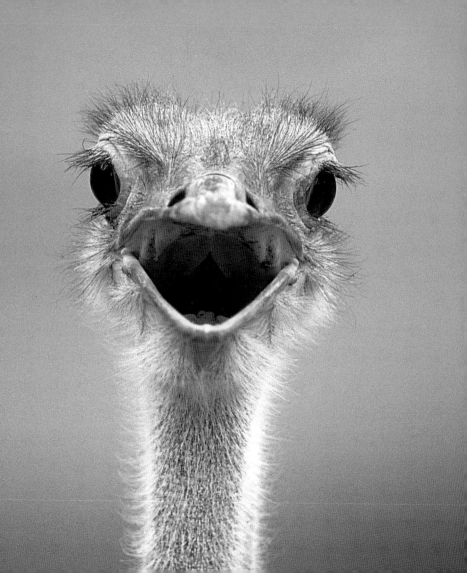

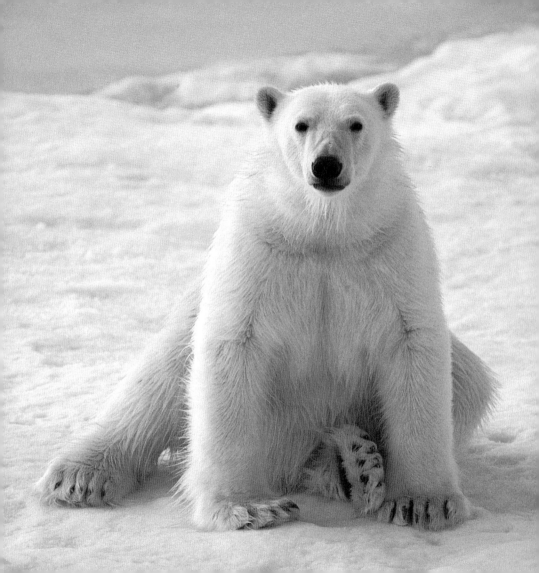

Middle age is when you choose your cereal for the fiber, not the toy.

Inflation is paying $20 for the haircut that cost $10 when you had hair.

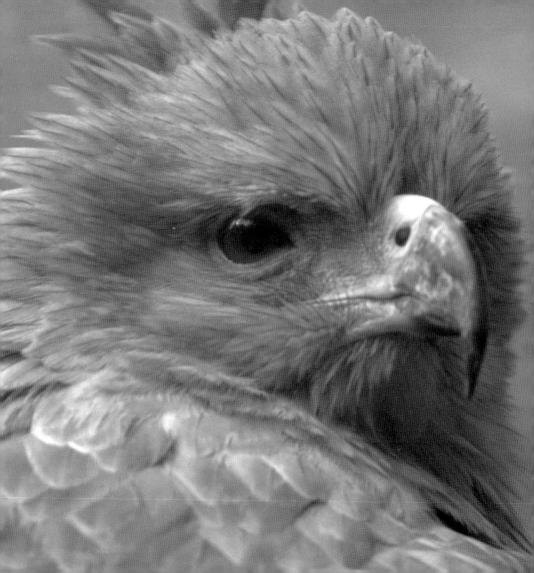

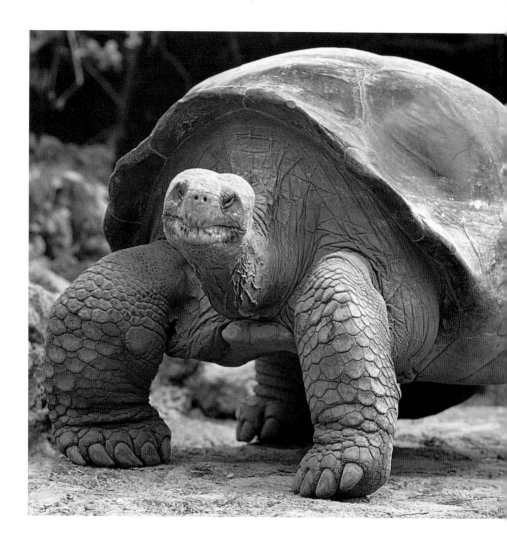

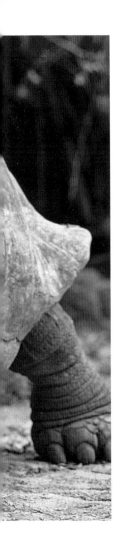

I still have a full deck;
I just shuffle slower now.